Something to Draw On

of related interest

Arts Approaches to Conflict
Edited by Marian Liebmann
ISBN 1 85302 293 4

Group Work with Children and Adolescents
A Handbook
Edited by Kedar Nath Dwivedi
ISBN 1 85302 157 1

Meeting the Needs of Ethnic Minority Children
Edited by Kedar Nath Dwivedi and Ved P Varma
ISBN 1 85302 294 2

Mental Health in Your School
A Guide for Teachers and Others Working in Schools
Young Minds
ISBN 1 85302 407 4

Violence in Children and Adolescents
Edited by Ved Varma
ISBN 1 85302 344 2

Play Therapy
Where Sky Meets the Underworld
Ann Cattanach
ISBN 1 85302 211 X

Child Play
Its Importance for Human Development
Peter Slade
ISBN 1 85302 246 2

Storymaking in Education and Therapy
Alida Gersie and Nancy King
ISBN 1 85302 519 4 hb
ISBN 1 85302 520 8 pb

Something to Draw On
Activities and Interventions Using an Art Therapy Approach

Carol Ross

Jessica Kingsley Publishers
London and Bristol, Pennsylvania

First published in the United Kingdom in 1997 by
Jessica Kingsley Publishers Ltd
116 Pentonville Road
London N1 9JB, England
and
1900 Frost Road, Suite 101
Bristol, PA 19007, U S A

Library of Congress Cataloging in Publication Data
Ross, Carol, 1947–
Something to draw on : activities and interventions using an art
therapy approach / Carol Ross.
p. cm.
Includes bibliographical references and index.
ISBN 1-85302-363-9 (alk. paper)
1. Art therapy for children. 2. Art therapy for teenagers.
I. Title.
RJ505.A7R67 1996
615.8'5156'083--dc20 95-41382
 CIP

British Library Cataloguing in Publication Data
Ross, Carol
Something to Draw on: Activities and
Interventions Using an Art Therapy
Approach
I. Title
615.85156

ISBN 1-85302-363-9

Printed and Bound in Great Britain by
Biddles Ltd., Guildford and King's Lynn

Contents

Part III – The Art Therapy Approach in Action

List of Figures

Appreciation

With appreciation to the Gulbenkian Foundation and to Islington Education for their financial support of the Art Therapy in Schools Project and to the schools, staff and children who have taken part.

Special thanks to Bronwyn Nkosi.

PART I

INTRODUCTION

Introduction

For many years now, I have been working with London schools on a range of equal opportunities and behaviour management issues. Through trying to understand what is at the root of underachievement and problematic behaviour, many considerations beyond the curriculum itself have been brought to my attention.

For many children, going to school means having to deal with difficult social dynamics, bullying and harassment (both inside and outside the classroom); having to measure their own ability and self-worth in relation to others; or finding themselves marginalised by the mainstream culture. Many children are coping with difficulties or hardships outside the school (such as family problems, bereavement, or exile) or arrive at school with low self-esteem, a poor self image and poor social skills. Concerns about achievement and behaviour, therefore, need to be addressed in a variety of ways.

In my work as an advisory teacher, a special needs teacher and an art therapist, I have long felt that children need to be supported on both an individual and an institutional level – that raising pupil performance and improving behaviour involved assessing pupils' specific needs in conjunction with considering the framework in which they must operate. This book offers an approach and activities for working with children on both personal and wider school issues.

The book arises from a project to develop a repertoire of strategic interventions which will support and raise children's level of functioning within the school context. The interventions are based on an Art Therapy approach, developed in relation to the school setting and presented within a curricular context. The project was funded by the Gulbenkian Foundation and Islington Education. It focused espe-

cially on the needs of children who are disaffected, particularly troubled or vulnerable or presenting behaviour problems. The interventions were piloted over a three-year period in both primary and secondary schools, in close collaboration with teachers, around a wide range of concerns. Sessions were organised on an individual, small group and whole class basis, as appropriate.

This book is not only for art therapists, but is also intended for teachers and other professionals, such as learning support staff, speech therapists, counsellors and youth workers, who would like to use this approach within the context of their work. It is organised into three parts: Part One discusses how to set up the interventions; Part Two provides ideas and activities for sessions, and Part Three outlines examples where these interventions have been effectively employed to illustrate the process in action.

WHAT IS AN ART THERAPY APPROACH?

It is impossible to explain what art therapy is in a few brief paragraphs. There are many different models of art therapy, rooted in as many different theoretical frameworks of psychotherapy and philosophies of creativity. It has a wide range of applications and art therapists work with many different client groups and in a variety of settings, including psychiatric patients, people with mental and physical disabilities, in hospices, prisons, hospitals, rehabilitation centres, family welfare centres, child guidance and schools.

Art therapists use image-making as a vehicle for exploring many facets of experience. Because art therapy puts great emphasis on process (as opposed to product) it does not require any particular skill or talent to participate.

An art therapy approach has been shown to be particularly suitable for working with children and young people and is adaptable to a range of contexts. It is an excellent way of working with children of varying ability and with mixed ability groups, as it allows each child to participate at their own level and to be valued for their contribution. It is an avenue of expression which can be used to develop communication skills and is an ideal vehicle for promoting self-esteem and raising confidence (both of which underpin pupils' willingness to 'take risks' in their learning processes, make mistakes and try

new things). It lends itself to theme work and can be adopted to the topic being studied. It is an effective way of exploring specific issues, problems or incidents. It can be used to promote cooperative behaviour and towards group building and it can help a child express things for which they have no language or are unable to say aloud. And it is enjoyable![1]

1 (With acknowledgement to Liebmann 1986.)

Setting Up Activities and Interventions

USES

There are many ways that an art therapy approach can be utilised and a range of concerns it can be adapted to address. The way it will be set up is determined by the nature of the context, circumstances and issues. It is important to allow time to 'unpick' concerns in order to pinpoint aims and focus and organise the activities and interventions appropriately. Here are some examples of ways it has been used in schools I have worked in.

Children marginalised within the class

To increase self-esteem, build confidence and increase a sense of their rights and entitlement with children who are withdrawn, vulnerable, being bullied, underachieving, have learning difficulties, or are marginalised through cultural or gender bias.

'Worst Class' syndrome

To create a positive dynamic, change relationships between individual pupils, teachers and the class as a whole, develop a framework for cooperative behaviour, and improve their collective image as learners with whole class groups caught in a negative dynamic.

Primary – secondary transfer

To build skills and strategies to cope with the demands of secondary school and offer emotional support through providing the familiar approach of themes, drawing, project and topic work and book-mak-

ing with year seven classes (during form time or within a curricular context of the humanities, PSHE or arts subjects).

Group-building
To build cooperation and trust, in a range of contexts.

Trouble-shooting
To use art therapy in a strategic way with difficult classes, groups or individual children in relation to a variety of concerns.

PSHE
To support various areas of syllabuses which are effectively explored through this approach and which rely on cooperation, sharing, personal reflection and building trust.

Social interactions
To shift dynamics, change roles, build social skills and develop mutual respect and understanding with groups of children and in relation to a variety of concerns.

Individual children
To build confidence, improve self-image, increase self-awareness and an understanding of their own behaviour, and provide emotional and psychological support with children causing concerns. It is also a means of assessing needs and developing strategies for working with the child back in the classroom and can contribute to formal assessment procedures.

Issues Forum
To allow a variety of issues to be aired, explored, shared and discussed.

Conflict resolution
To promote understanding of conflict situations and support a 'problem solving' approach.

Communication skills

To improve talking and listening skills, develop the ability to share experience and build confidence with various groups of children, including perpetrators, bilingual learners and children with poor communication skills.

Bullying and harassment

To explore incidents and issues from different angles, support victims and work with perpetrators.

Pastoral staff

To support the work of pastoral staff in various roles.

GROUPING

Art Therapy activities and interventions can be organised on an individual, paired, small group or whole class group basis. Grouping needs to be decided in terms of the identified aims. For example, using it to support group-building, alter group dynamics, or cover aspects of a syllabus or programme will obviously be organised on a whole class basis. However, where interventions are being organised around the needs of specific children, there are a number of considerations that should be taken into account:

- ○ Will the aims best be realised on an individual, paired, group or whole-group basis?

- ○ How will the child respond to being 'singled out'? Will it allow them some space and individual support, or will they feel stigmatised? Will it reinforce an undesirable view they have of themselves or the class holds of the child? Would organising a group activity would be more appropriate?

- ○ Who can the child be paired or grouped with most beneficially in relation to concerns about their behaviour, friendships, social skills, or confidence? Can images held by (and of) the child be improved through grouping them with the 'bright' or the 'good' children? Who will help them to

break out of an entrenched role, build a new friendship group, work on social skills and be seen in a positive light?

OTHER CONSIDERATIONS

Who should run the sessions, how staff will liaise, and when, where, how often and for how long sessions should be held are, of course, restricted by practical constraints. Nonetheless, they are important issues worth considering:

- Is the class teacher the best person to run the sessions or would a 'neutral' person such as a special needs or learning support teacher be most appropriate? Sometimes, an outsider or specialist teacher or counsellor can develop a different sort of relationship with the child or group and allow a different dynamic to emerge. However, teacher-led sessions can promote a situation whereby a better relationship can be established and old patterns of response can be altered.

- What are the benefits of running sessions within the classroom or of having a 'special place' to meet? Will a meeting outside the classroom allow children time and space and a chance to 'be different', or will it marginalise them further?

- Can time be set aside for staff to liaise and communicate with each other about developments and outcomes of the sessions so that changes can be reinforced, built upon and carried over into the classroom or other classrooms and outside the classroom?

- What is the optimum timing and duration for the sessions in relation to the concerns, aims, organisation and context? Will the class, group or individual child benefit from ongoing support or will a limited and strategic period be most effective?

MONITORING OUTCOMES AND REVIEWING AIMS

It is extremely useful to monitor developments, progress, other outcomes and issues arising with the individual child, group or whole

Art Therapy Sessions – Monitoring Sheet for

	In general	In particular context		Other
		Before	After	
1 Is the session a positive experience in itself? ◦ How does the child anticipate it? ◦ How does s/he talk about it? ◦ What state is s/he in directly afterwards?				
2 Are there any observable changes in the child's levels of confidence?				
3 Are there any observable changes in the child's levels of cooperation?				

	In general	*In particular context*	*Before*	*After*	*Other*
4 Have you noticed any differences in the child's 'role' or status within the class?					
5 Are there any observable changes in the child's friendships?					
6 Have you noticed any differences in the child's social interactions or groupings?					
7 Additional information or comments?					

class during the sessions. This can be done in various ways, for example:

- Keeping an ongoing record of the general behaviour of groups of children or whole classes.

- Keeping a diary of the sessions, noting emerging issues and assessing changes in the children's perceptions and feelings about themselves and in relation to the school context.

- Periodic interviews, discussions or consultations with other staff, the children and parents or carers to compare perceptions, observations and concerns.

- Having the children keep a diary of their school experiences, feelings, ups and downs, etc.

- Class teachers keeping a record on individual children withdrawn for sessions run by another staff member (see example, pp.10–11).

Monitoring can serve as a basis for reviewing the effectiveness of the sessions, reappraising the approach, targeting specific concerns and observing their impact. As the sessions continue, aims will need to be adjusted, refined or refocused as some issues are resolved and others emerge.

INTRODUCING THE SESSIONS

It is central to the effectiveness of the sessions that children view them in a positive light and not as a 'remedial' activity. It is essential that sessions are regarded as a 'treat' or a 'privilege' or even as 'fun' to avoid falling into the trap of inadvertently reinforcing a 'deficit' model of the children. The way it is introduced to the children is therefore crucial.

Because sessions are often organised in response to concerns over behaviour or performance, it is only too easy to introduce them in negative terms. (For instance, 'we have organised these sessions because you don't know how to work together', or 'because of your behaviour' or 'because you don't join in or speak out'.) Sessions should be introduced in terms which:

- reinforce the aims of promoting a better self-view and building self-esteem

- raise the status of the child or children involved

- allow the children to identify the sessions within the normal school context.

Art therapy activities and interventions can therefore be adapted to and presented within a curricular context so that children can regard it as a 'normal' part of school life. The area being studied can become the context for the way the sessions are presented and a foil for working towards the identified aims. It is, in fact, these aims rather than the curriculum itself, which are the true focus of the sessions.

Children who will be withdrawn for individual or group sessions can be 'selected' to work on a 'special project' (possibly one which might be presented to the class or the Head, or Head of year). Whole class sessions may be presented in terms of book-making, journal keeping, individual or collective projects, preparing a display or exhibition, or as an enjoyable (or, at least, valid) way of exploring an issued or topic area.

To give an example of how this can work in practice, I'll describe two situations:

1. One primary school-aged child was causing great concern because of extremely withdrawn behaviour. Individual sessions were organised with the aim of assessing what was behind this behaviour. These were focused around 'growing and changing', the class theme for that term. To avoid the child feeling singled out or being further marginalised, and to develop his interactive skills, he was 'chosen' together with another child. During the sessions, they each made a 'special project book' about themselves.

2. A secondary school social studies class was particularly unsettled and disruptive. Sessions were organised aimed at group building. These were presented as part of that term's topic on 'adolescence', but focused on developing cooperative behaviour. Their drawings formed part of their folders.

THE APPROACH

An art therapy approach involves using image-making as a vehicle for realising aims other than the production of polished art objects or the imparting of the art curriculum. The art activities serve as a vehicle for exploring feelings, ideas and events, developing interpersonal skills and relationships, increasing self-esteem and confidence and promoting a stronger sense of self and self-image. Depending upon the focus, the activities and organisation will vary, but there are some key elements which are central to the approach.

Non-judgmental acceptance of all artwork

There is no 'right' or 'wrong' way in an Art Therapy approach and this must be made clear. Children need to feel secure in the knowledge that the image-making is a way to record their experience or represent their thoughts and feelings, and they will not be judged on its merit.

Children as experts

The activities are devised in such a way that allows each child's experience to be the starting point. In this sense, children are the 'experts' of their own images.

Every contribution valued

In the same sense, every child has a valid and unique contribution to make. All work needs to be valued with equal respect, regardless of its proficiency.

Protecting privacy

Because activities have the potential to be taken at quite a personal level, children's privacy needs to be safeguarded. No child should ever be encouraged to reveal more than they do of their own accord. It must be left to each individual to decide at what level they wish to enter into the activity.

Sharing work

The context for sharing and discussing the children's work needs to be 'non-invasive'. No child's work should ever be interpreted (except by themselves, if they wish to) and children must never be pushed into disclosing more than they are comfortable with.

Ground rules

In paired, group or whole class situations, it is useful to establish some basic ground rules. These should be to do with ensuring mutual respect, valuing each other's contributions and generally aimed at keeping the environment safe and creating a situation whereby all the children can feel good about themselves (see example on p.16).

Process and product

Although the Art Therapy approach puts emphasis on the process of image making as well as the image itself, it is important not to underestimate the significance of the product to the child's sense of accomplishment and self-esteem.

Ways of working

Activities can be constructed in different ways. They can be highly structured or left quite open. The way of working is determined to some extent by the confidence and attitude of the children, but is primarily determined by the underlying aims. For instance:

- Working with a class towards developing cooperative behaviour may involve a very structured approach, with each child clear about what they are expected to contribute and how it relates to a greater whole.

- A child withdrawn for assessment purposes may be left to establish the starting point, with the adult following their lead.

- A theme relating to the curriculum can be set in very broad terms and allow children a lot of scope for interpretation.

- The exploration of a specific issue, incident or concern may be tightly focused.

EXAMPLE OF GROUND RULES

1. Listen carefully to each other.

2. Allow each other to speak without interruption.

3. Respect each other's views/opinions.

4. You do not have to take an active part in the lesson if you do not want to.

5. Everyone must feel comfortable in the lesson – including the teacher.

6. Everything said in this lesson must be confidential – unless agreed otherwise.

Completed work

There needs to be a means of keeping the children's images which enhances their pride in it. There are various possibilities here, which can be built into the nature of the activity or 'project'. Examples include special folders or portfolios, book or journal making, or mounted displays (any of which can be organised on an individual or collective basis).

CHOICE OF MATERIALS

Any of a wide range of creative materials are appropriate to an Art Therapy approach. Activities can be organised very modestly, with only pencil and paper, or with a wealth of choice. Aside from practical constraints, there are important considerations around selecting materials in relation to both the aims of the sessions and the personalities of the children, such as:

- Choice of materials affects the way in which activities are engaged. Some materials, such as pencils, crayons and felt tips, allow 'tighter' control, while others, such as pastels, paint and clay, can give rise to 'looser' and 'freer' expression.

- If children are tentative, unsure, or wary, they may feel safer with materials which are most easily controlled.

- In the same way, it can feel safer, more contained and reduce a 'sense of chaos' to begin with 'controllable' materials with children or groups whose behaviour is difficult to manage.

- Many people feel unconfident about their art ability. Cutting out magazines to make pictures (collages) can be a great 'leveller' and encourage even very unconfident children to join in.

- Once all children are confident about engaging in the activities, materials such as paint or clay can give rise to deeper and wider self-expression. This can be especially valuable when exploring feelings or responses to emotional issues, such as bullying.

- Working with expressive materials can be in itself 'therapeutic' for many children. Not only can it give vent to a

wide range of emotions, but the act of manipulating clay or smearing pastels or brushing paint – with undue concern with the end product – can in itself be a healing experience.

ACTIVITIES USING AN ART THERAPY APPROACH

Introduction to Using the Activities

This part of the book consists of a collection of ideas for activities based on an art therapy approach. Most of them can be organised on a whole class, group or individual basis and adapted to different contexts. Many can be modified to fit into a wide range of themes or topics.

The activities can be presented as one-off sessions (e.g. to support other types of work or for assessment purposes) or as a series over a period of time. Depending upon the aims of the sessions, various combinations of activities can be selected and worked on in different ways (for instance, as a project book or journal, folder, or display).

There are a variety of ways of starting off the activities. Some depend upon an initial discussion or brainstorm of ideas; some start off with simple directions; and some are interactive throughout. I often use a workshop format when working with whole classes or groups, with a formalised introduction and structured sharing and feedback times. This approach is especially effective for group building sessions, developing cooperative behaviour, promoting confidence or talking and listening skills. However, I usually find a more open or interactive approach more suitable for working with individual or small groups of children.

Before every session, children are reminded that this is not an 'art lesson' and there is no 'right or wrong'. They are told there are many different ways of putting down their thoughts, ideas or feelings in image form:

- ◦ as a representational image
- ◦ stick figures
- ◦ in cartoon form
- ◦ through symbolic imagery
- ◦ through non-representational shapes, colours, forms and texture
- ◦ through a combination of these
- ◦ using any combination of media they choose.

EXAMPLE OF A PROJECT BOOK

The Book About Me

Cover Representations of various aspects of my life (e.g. hobbies, interests, family, favourite things, activities)

Contents My various roles

What I like about me

Happy Box

Trunk of things that upset me

A room of my own

Images of contrasting feelings

Inside/Outside Portraits

Mood pictures

EXAMPLE OF WORKSHOP FORMAT

Babylon 5

Length of session: 1 Hour 10 Minutes.

Materials: Scissors, gluesticks, magazines, felt-tips,
coloured sugar paper.

1 *Introduction to the activity* 5 minutes
 (Ground rules for the sessions)

2 *Guided fantasy* 5 minutes
 (Spoken aloud while participants
 listen with eyes closed)

3 *Activity* 30 minutes
 (Individual image-making)

4 *Sharing in pairs* 10 minutes
 (Explaining their pictures to
 each other)

5 *Whole Class Sharing* 20 minutes
 (One thing you or your partner
 put in your/their picture and why)

 Alternative
 (Two or three pairs join together
 and share)

Feelings

MOOD PICTURES

These pictures illustrate moods or feelings, using only shapes, lines, colours, textures, tone, etc. – but no representational images. They can be used in relation to a variety of focuses, for instance, 'your mood right now'; 'how you felt when'; or in relation to specific situations.

They are best introduced with discussion about how different colours and shapes can suggest or inspire different moods. (For example, red may express excitement, anger or energy, smooth shapes may be calmer than spiky shapes.) However, it is important to remember that this varies with the individual and also with different cultures. Colours and shapes should never be prescribed in relation to moods or feelings, nor ever interpreted.

FEELINGS

This activity begins with a discussion about what feelings are about (where they come from, why we have them, what they tell us) and a brainstorm of different sorts of feelings (e.g. happy, sad, angry, surprised, bored, embarrassed). Children draw a face which illustrates any particular feeling they choose. (Make it clear that cartoons and stick figures are perfectly acceptable.)

'Why is their face sad/happy/surprised? What is their character thinking about? Why?' This is represented in a large 'thought bubble' above the face. (This part of the picture can be represented in any form, including non-representational.) Then another or several other pictures are done, using the same face, each showing a different feeling.

Figure 1a: Feelings

Figure 1b: Feelings

The pictures can be used as a basis for telling stories about the characters, or stringing them together as a 'story board'. This activity forms a good basis for developing creative writing or poems about feelings.

HAPPY BOX

(Introduced as a visualisation.)

> 'Imagine you are given a magic box. It can be as big as a shoe box, a house, or even bigger. This box will hold only happy things. You can put all the things that make you happy into the box and they will be kept safe. You can go into your Happy Box whenever you need to cheer yourself up. What will you put into your box? Close your eyes and think of things that make you feel good. Draw or construct your Happy Box and fill it with images of whatever you like.'

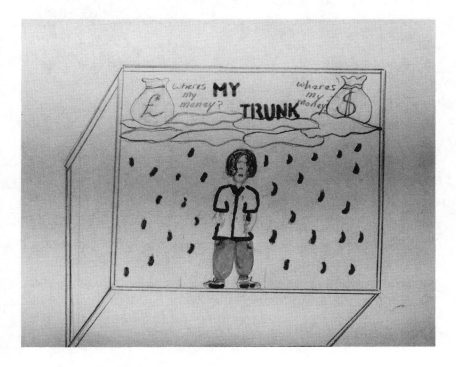

Figure 2a: Happy Box

Figure 2b: Happy Box

TRUNK OF THINGS THAT UPSET ME

(Introduced as a visualisation.)

'Imagine you are given another enormous box, but this one is really a magic trunk that you can lock up. You can put all things that upset you or anger you into this trunk and it will hold them securely. Nothing can escape from the trunk. But whenever you want to think about something or work out what to do about it, you can take it out of the trunk. And you can put it back again when you have had enough of it.

'Draw or construct your trunk. Then draw or construct images of things that upset you or make you angry and put these into your trunk.'

IMAGES OF CONTRASTING FEELINGS

These lend themselves well to large group feedback sessions, done in a round – but with the option to pass – and possibly recorded on the board or flip chart.

The two contrasting images can be on the same sheet of paper, divided into two, front and back, or two separate sheets.

'I love it when...'

'I hate it when ...'

'I felt good when ...'

'I felt bad when ...'

'I like ...'

'I don't like ...'

CHAPTER 5

Self

AUTOBIOGRAPHY

'Can you draw your life? Make a picture about your life showing important things that happened, big changes and things that mattered to you. For example, do you remember when you started school? Did you move house? Did someone come to stay? Did someone die? Do you have any particularly happy or sad memories you want to include?

'There are many ways of drawing your life. It might be a curling line, with special points on it, or it might look like a map. It might be all different pictures blending together. You can draw your picture any way you want.'

PAST/PRESENT/FUTURE

This activity helps explore the way that people and things change; to express things they have experienced; to share current experiences; and to share hopes and fears for the future. Because the concept of past, present and future is relative in nature, it can be complicated for younger children to understand. It is important to begin by discussing what we mean by these terms and the different way they can be used (e.g. yesterday, today, tomorrow; last year, this year, next year; last century, this century, next century). Children are then asked to represent and share experiences, feelings and expectations of things to come. This activity can be very useful to use with refugee and immigrant children. It can also be a valuable way of working on an individual basis with children who have experienced abuse or trauma.

BABYLON 5
(Introduced as a guided fantasy.)

'You are taking a trip into the unknown to the Babylon 5 Space Station. You are leaving everyone and everything behind. You don't know when or if you'll return or see anyone again. You are allowed to take only one container with you, which you can use to put in whatever you want.

'You may choose anything you like to bring with you, but choose carefully because its your only chance.

'Draw or construct your container and fill it with pictures, drawings or models of whatever you want to bring.'

SAFE PLACES
(Introduced as a guided fantasy.)

'Close your eyes and imagine a room where you feel warm, happy and completely safe. This room belongs only to you. No one can hurt you there and no one can come in unless you want them to. What is in your room? Is there a bed, table, curtains, carpet? Is there a chair? Is it big and soft, or wooden and hard? Are there windows? Do you have a view or are the curtains drawn? Are there shelves? What is on them? Are there magazines or books? Soft toys? Games? Is it bright or dark? Keep your eyes closed for another minute and just look around at your safe cosy room.

'When you open your eyes, draw your room in as much detail as you can.'

ME IDEAS
These ideas are useful triggers for sharing, getting to know each other and building self-esteem. They fit well into a 'personal diary' or 'book about me'.

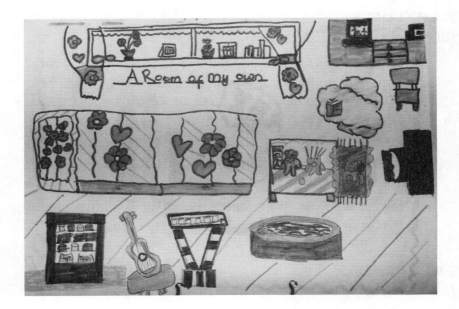

Figure 3: Safe Places

Map of myself

> 'Draw a picture that shows different aspects of your personality. What is your nicest self like? What does your angry self look like? What about your scared or brave selves? We all have many sides to our personalities. You can represent the different parts of yourself any way you like.'

(This is useful for exploring behaviour while building self-esteem and self-acceptance.)

Dreams come true

> 'Your dream has come true – Draw it!'

I wish

> 'I wish that ... – Draw it!'

Favourite thing

'What is your favourite thing in life? – Draw it!'

My dream

'Can you remember one of your dreams? Was it funny, weird, confusing, scary, happy? – Draw or paint it.'

PATCHWORK QUILT

This activity is designed to allow children to explore their cultural heritage, appreciate each other's and begin to understand the complexity of cultural identity.

The children are asked to consider their cultural backgrounds – where did their parents come from? Their grandparents? Their great-grandparents? What did they do for a living? What part of their country did they live in?

What about their lives now? Their surroundings? Their family? Their friends?

'Make a "patchwork quilt" which represents your individual cultural identity. Everyone's quilt will be different. Let each square of your quilt represent a different element of your cultural heritage. All the squares join together to form a unique identity.'

The quilts are made of paper. They can be done on a single sheet or on separate squares which are pasted down. The squares can be filled in any way the person wishes – with symbols, pictures, or other images.

Completed quilts are shared in a group 'appreciation' session at their completion.

INSIDE/OUTSIDE PORTRAITS

'What do other people see when they look at you? How do they see you? What do you show them?

'How do you feel inside? Is it different from what others see?

'For example, people may think you are brave but you may feel scared inside, or people may think you are weak, but you may know you're strong inside. Others may see you as calm and happy, but you may not feel like that inside.

'Draw or paint two portraits of yourself, one how you look on the outside, the other how you look from the inside.'

(Reminder: Any style of representation can be used or combined.)

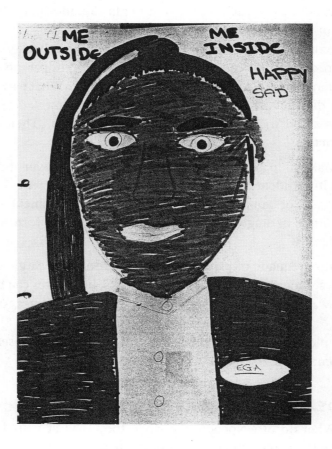

Figure 4a: Inside/Outside Portrait

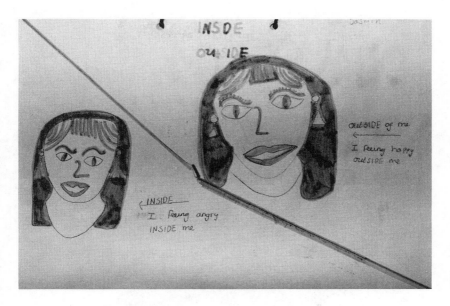

Figure 4b: Inside/Outside Portrait

I AM …
(*Introduced as a visualisation*)

> 'Everyone has many roles and has different relationships with different people. You might be a daughter or son, student, big sister/brother, little sister/brother, grandchild, niece/nephew, cousin, friend, baby-sitter, worker, or team member. Think about your life and all the roles you have. Do you feel different in different roles? Are you happier in some than others? Which roles make you feel important or grown up? Which make you feel small?

> 'Create a picture that shows your various roles. Can you find a way to show what you do in your different roles – or how you feel in them?'

Figure 5a: I am...

WHAT I LIKE ABOUT ME

> 'I like myself when ...'

(It may be helpful to begin with a general discussion, e.g. 'what makes us feel good about ourselves', or about qualities and behaviours we value.)

> 'I feel weak when ...'

> 'I feel strong when ...'

Figure 5b: I am...

'I felt safe when ...'
'I feel scared when ...'

'I'm happy when ...'
'I'm sad when ...'
'I'm angry when ...'
'I'm silly when ...'

Bullying, Harassment and Conflict

Here are a number of art activities that lend themselves to exploring issues connected with bullying, racial, sexual or other forms of harassment, or conflict situations. The ones on this page set the scene by exploring rights and the notion of self-assertion.

OUR RIGHTS

1. 'What are our rights?'
 (A brainstorm or discussion of our human rights or our rights in relation to a specific area of our lives, e.g. in school, in the playground, etc.)

2. 'Visualise a situation where we depend on our rights. Now visualise those rights being violated. How does that make you feel? Do a picture that shows how this affects you.' (Share and discuss.)

3. 'Visualise yourself protecting your rights. Can you see yourself standing up for your rights? Can you see yourself standing up for your rights in a way that won't violate someone else's? How does this make you feel? Do a picture that shows how this affects you.' (This can be developed into a discussion of positive ways of dealing with conflict.)

Figure 6: Our Rights

4. 'Body Language'
 'Can you draw pictures (or find in a magazine) that show
 our body language giving different messages? (Pictures that
 show how we let people know we feel weak or strong,
 happy, sad, angry, or aggressive, passive – using words – just
 through our posture, expression, eyes, etc.)'

WHY DO PEOPLE BULLY?

This activity helps children to explore bullying in a more direct way.
Without allowing a judgmental or punitive atmosphere to develop,
children are asked to explore the nature of bullying and why people
bully.

Whenever I have used this activity with children, issues of the pain, sense of inadequacy, or previous abuse have surfaced as explanations. This has helped vulnerable children to understand bullies as children who are also vulnerable, and this can be empowering. It can also help children who bully recognise that their behaviour involves taking their own problems out on other people in order to feel better.

It is most important to recognise however, that discussion, assertion and self empowerment work and empathy exercises are not in themselves sufficient to stop bullying. Work with children must run alongside developing systems and procedures to deal with incidents.

1. Discussion

 ◦ 'What is bullying?'

 ◦ 'How does being bullied make someone feel?'

2. Why do people bully? Can you think of a time you have been a bully, or seen someone else being a bully? Imagine you are that person for a minute. Why are they doing it? How does it make them feel while they are bullying? How do they feel later on? What do they think about themselves?'

 Children do images (as pictures or with clay, if available) to represent what's going on for the person who bullies others.

3. Sharing
 Children can share in pairs or small groups, and then feedback 'key issues' to the whole group. Comments can form the basis for further discussion and linked to other activities (e.g. 'How does bullying violate our rights? What can we do to protect people who get bullied? How do we help people who bully learn to behave more constructively?')

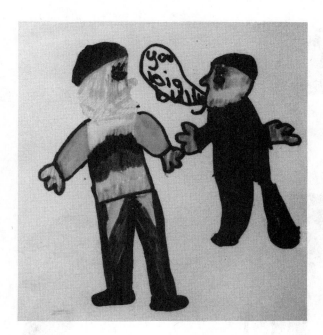

Figure 7a: Bullying

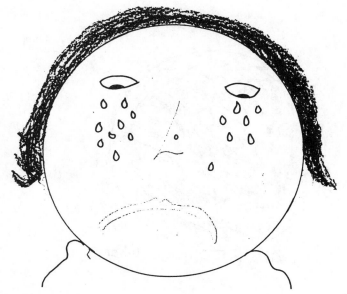

Figure 7b: Bullying

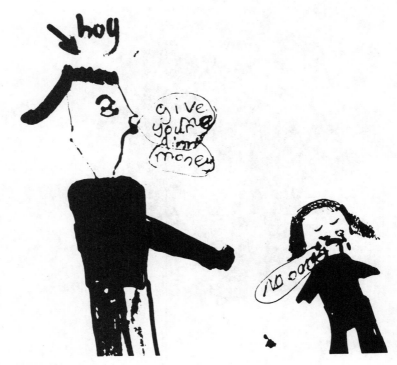

Figure 7c: Bullying

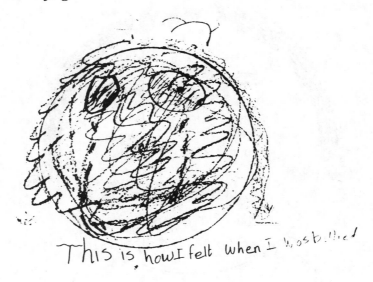

Figure 7d: Bullying

ROLE PLAY IN ART

This activity can be used in relation to a number of situations or issues. I have found it an especially useful way of exploring incidents and increasing understanding and empathy.

1. Brief story, description, or video which 'sets the scene' or describes an incident and the characters involved (or the children may describe an actual situation or write their own).

2. In groups, each member takes the role of a different character from the story, illustrating the scenario from their point of view (for instance, 'How did your character feel? What happened next? Who did they go to?').

3. Share in 'role play' groups ('What does your picture show?').

Follow on

The story or description can be discussed in terms of other possible outcomes or ways of handling it. ('What would happen if your character did this or said that?') New images can then be made illustrating how the impact of the event would be different for their character. This is a very useful way of exploring how our behaviour affects others and can influence what happens next.

Variations

○ One child can take the role of all the characters in turn, through a series of pictures, to explore the impact of an event or incident from different positions.

○ As situations (without a story):

'You're the bully; you're his/her victim; you're watching it happen.'

'You're new here; you're well established; you're the friend of the second person.'

'You're an older child in the playground; you're a younger child; you're an adult.'

'You're lonely; you're angry; you're sad.'

FEELING GOOD AND CONFIDENT

1. Discussion:
 'What do we mean when we say we feel confident? What "messages" do we give ourselves and get from other people that help us to feel confident? Can you think of situations that it is helpful to be able to feel confident?

2. Image making:
 Children are asked to make images of themselves feeling good and confident in relation to situations they find difficult. They are asked to consider what they would be thinking about? How would they be feeling? What would they be saying to themselves? ('Imagine yourself ...')

PROUD OF MYSELF

'When are you proud of yourself? What were you doing? What were you feeling? Visualise yourself being proud and try to get the feeling back. Now represent it in a picture.'

Figure 8a: Proud of Myself

Figure 8b: Proud of Myself

Variation

Some children find it hard to express what they like about themselves in direct terms. This activity can be set out in terms of 'things I do well' (e.g. interests, hobbies, helping out, work) and then the notion of pride can be developed through discussion.

MAKE IT BETTER

This activity helps children understand and gain faith in the process of reparation – that things can be very bad and get better. This is especially useful in situations requiring action to improve, but where the child feels powerless (such as in a bullying situation or in conflict with a more powerful child).

(In threes)

Child one – Makes a shape on a piece of paper (non-representational)

Child two – Spoils it by drawing a few lines over it

Child three – 'Repairs' it by adding to the picture, incorporating the lines into a 'new' picture.

Variation (In pairs)

Child one – draws an 'ugly shape'.

Child two – adds to it to turn it into a 'nice picture'.

WHAT HAPPENED?

(This activity is intended to help children to consider conflict in 'problem solving' terms.)

(In pairs)

1. Each child draws a representation of a conflict situation or disturbing incident.

2. In turn, they share their pictures with each other – what happened? Why? What can be done to make things better now?

FRIENDSHIP

1. (Visualisation)

'Close your eyes and think about yourself as a friend. We are all able to be a good friend to people we care about, at least some of the time. What kind of a friend are you?

'Pretend you are friends with yourself. What sort of problems would you take to yourself for help with? What things would you be fun to do things with? What will you help with? What can you share with yourself as a friend?'

2. Picture

'I'm a good friend because ...' in image. (Each person can represent their qualities as a friend in any way they want to, for instance, as a visual story, an assortment of images, mood pictures.)

Follow up

The pictures can serve as a stimulus to discuss what they value in a friend and become conscious of their own qualities. We have used them as a trigger for a class 'brainstorm' (see Figure 9) about qualities

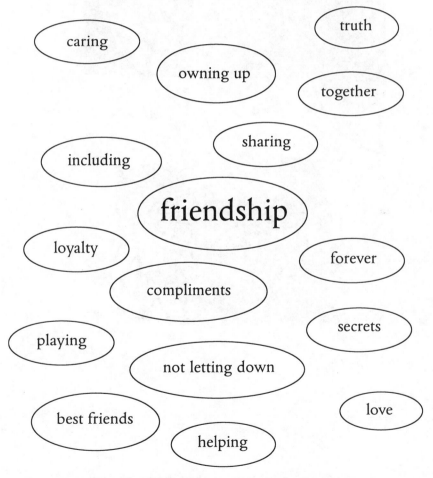

Figure 9: Example of brainstorm introduction to Friendship Project

of friendship, and as a basis for creative writing and poetry. It can also serve as a way to explore the subtler forms of bullying, such as excluding someone from a group or activity, or making friendship conditional on joining into behaviours that are uncomfortable or anti-social.

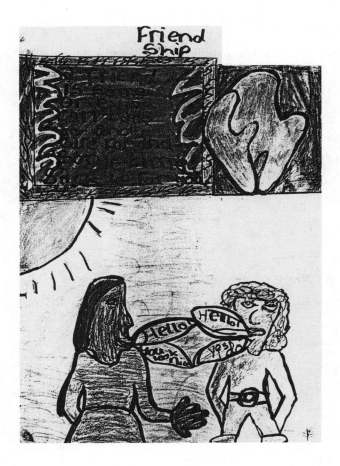

Figure 10a: Friendship

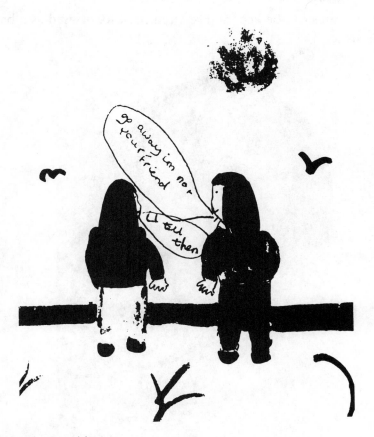

Figure 10b: Friendship

OVERCOMING

These are really visualisations in art. In the first picture, the child represents a situation that causes fear or anxiety (such as speaking in front of a group, confronting someone or dealing with a bully).

> 'Try to get the shape and feel of the fear into your picture. What is it about? How does it look?'

In the second picture, the children represent themselves overcoming it or standing up to it (for example, standing up to the bully, speaking in front of a large group, telling someone why they're angry or hurt).

'Draw yourself doing the thing that you are anxious about. How does it feel to be able to do it? How does it look?'

(These pictures can be kept and referred back to, or used as a basis for discussion.)

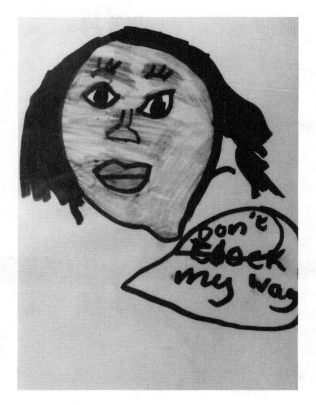

Figure 11: Overcoming

FEEL LIKE/CAN DO

This is an approach I developed for working with children on their behaviour which proved very effective. In the first picture, the child represents a situation or incident where they were extremely angry.

After the child explains the picture, they are asked to do a second picture, representing how it made them feel or what it made them feel like doing. This picture is 'imaginary' and they are allowed to express their fantasies without censor, no matter how vengeful or

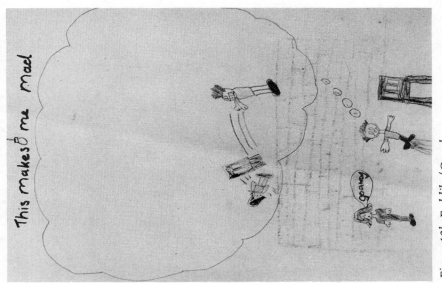

Figure 12b: Feel like/Can do

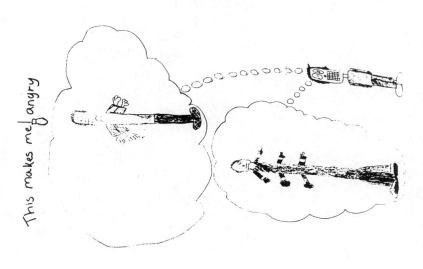

Figure 12a: Feel like/Can do

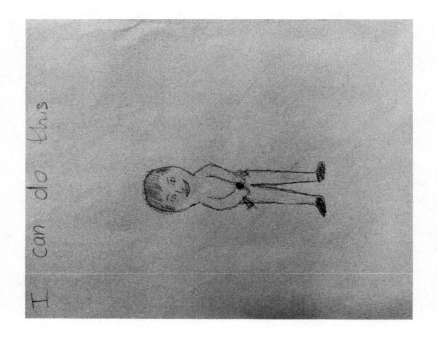

Figure 12d: Feel like/Can do

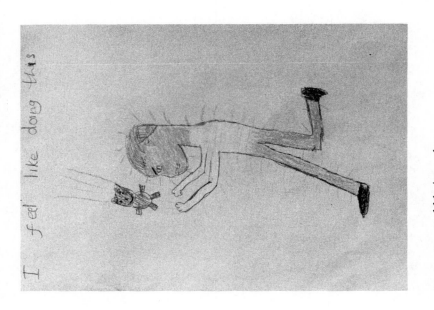

Figure 12c: Feel like/Can do

violent. This picture is then explained (always in terms of being imaginary).

In the third picture, the child represents what they actually can do, following discussion about acceptable ways of expressing anger.

This activity seems to be helpful to children in that it both validates their right to be angry, while helping them develop strategies for dealing with their anger.

Body Image

There is much evidence that even quite young children can develop a distorted body image and there is concern over the growing number of children with eating disorders. We are all subjected to an onslaught of media images of 'perfect bodies'. Research is showing that many children are very vulnerable to these images. Much bullying revolves around picking out the aspects of their appearance that children are most sensitive about.

Art therapy activities are an ideal way of exploring body image (and media pressures) with children. It can help children gain self awareness and awareness of the pressures they are subjected to and their perceptions about their bodies, and raise self-esteem and confidence. But it can be an extremely sensitive area and should not be entered into in a group situation unless there is a very supportive environment.

The following activities are some examples of how an art therapy approach can be used to explore these issues.

WHAT THE PAPERS SAY

'In the paper, in magazines, on the television, in the movies – we see images of women and men who are supposed to be beautiful. It can make us feel that we are not beautiful unless we look like them. Let's take a fresh look at who we're "meant" to look like.'

Images are cut out of magazines and composed into new images. (Bits of bodies may be put together, or whole figures rearranged.) Images

can be as bizarre or surreal as people like and worked on individually or collaboratively.

Finished images are put together, compared and discussed. (The exaggerated images highlight the pressures and absurdity of the 'norm'.) 'How do the images affect us and our self images? How do they influence our ideas about how we should look?'

MAP OF MYSELF

Many young people see themselves in 'bits', focusing on features or body parts separately. Often they will have strong dislikes about aspects of their bodies. This activity allows scope to explore fragmented and negative self-perceptions and begin to move towards an integrated and more positive self-view.

First 'map'

'Shut your eyes, sit comfortably and tune into your body. Let your awareness move to a part of your body you are comfortable with or feel good about. Then move to a part of your body you are less comfortable with, feel bad about, or is less relaxed.

'Be aware of the memories or tensions each body part may be carrying. Represent those parts of your body you have focused on as a map. Show how you experience different parts of your body.

'You can use colour and shape and scale (size) to show how beautiful, ugly, important, unimportant you think each part is.' (Discuss the images with a partner.)

Second 'map'

'In your second "map", join all the bits together so it forms one single image, instead of lots of parts. For instance, if your first map looked like a group of islands, your second "map" should look like a major continent. Use colour, shape, texture to make your map of yourself as beautiful and distinctive as possible. As you create your image, be conscious of bringing each part into

the whole in a loving way. Create an image which accepts all aspects of your body.'

(Compare the second images as a whole group. Each is different, each is unique. If you took away or changed any part, it would no longer be the same image. It can be nice to mount these together, each image contributing something special to the whole.)

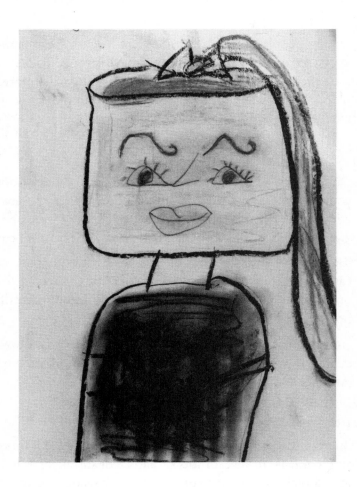

Figure 13: Map of Myself

BODY PICTURES

Each takes it in turn to lie down on a large sheet of paper, while a partner draws an outline around them.

People colour in their own life-sized outlines. (They are asked to be as true to life as possible.)

These body-pictures can form the basis of discussion, highlighting various issues. (Are there obvious areas that have been exaggerated? Left out? What does the way they've been coloured in say? What does the person feel about their images? What do they think they look like? Why?)

Variation

Instead of filling in the outlines in a 'true to life' way, they may be filled in 'emotively'. (Colour in the areas that please you/upset you/are tense/where your fear lives/where your confidence lives, etc.)

Group Building

DESCRIBE AND DRAW

In pairs, children take it in turn to describe (line by line) a drawing which they've done earlier to their partner who cannot see it. The second child must recreate the drawing through verbal instruction only. This is great fun and develops talking and listening skills, and collaborative behaviour.

BEAUTIFUL GARDEN

'If you were a plant, what would you be? What would your leaves look like? Would they be spiky or smooth? Would you have thorns? Would you have flowers? What colours would they be?'

Everyone draws themselves as a different variety of plant, real or imaginary. Each person can explain their image if desired (preferably in pairs). Then these are cut out and arranged on a large sheet of paper, forming a single beautiful garden. (Borders etc. can be added.)

This activity is especially useful for group building, developing cooperative behaviour and improving the collective group identity.

FRUIT SALAD/VEGETABLE SALAD

These are variations of the above. Everyone draws themselves as the fruit/vegetable of their choice (that they feel most resembles or expresses their appearance and personality). These are cut out and mounted on a picture of a large salad bowl.

Figure 14: Beautiful Garden

FOLLOW THE LEADER

I devised this activity to enable withdrawn, fearful, or passive children to take the lead and feel powerful. The children I've done this with have loved it.

(In groups)

Child one draws a picture, line by line. After each line, time is allowed for the rest of the group to copy it. Only the child in the lead knows what the final picture will be. It is also fun to compare the final outcome to see how similar and how dissimilar the pictures are.

CONSEQUENCES

This is an old art game, but I found it a useful interactive activity that builds cooperation and shows the importance of communication.

(In groups)

1. The group agrees a theme (e.g. an animal, person, doctor, fire fighter, etc.).

2. The figure/subject is divided into three, four or five parts depending on the numbers in each group (e.g. head, body, legs, feet).

3. A sheet of paper circulates, with each child adding their part of the figures, folding it over (so no one can see it) and passing it on.

4. When all have had their turn, the paper is unfolded and the figure seen as a whole.

THE ART THERAPY APPROACH IN ACTION

In this section, there are brief case histories outlining different ways I have used an art therapy approach in various schools. These sessions were set up as strategic interventions and were organised and evaluated in relation to specific concerns. All the work was carried out in close liaison with the teachers, head teachers (primary), form tutors and heads of department (secondary). Parents and other professionals (e.g. social workers and educational psychologists) were involved where appropriate. Aims for the sessions were identified through consultation and centred around helping the children improve their level of functioning within the school context.

EXAMPLE I

Lower Junior
Art Therapy Group Work with Year 3 Pupils

Focus of concern

There are two boys in this class (T and L) who exhibited particular emotional and behavioural difficulties, and three others to a lesser degree. T and L appeared to 'spark each other off' (mainly 'set off' by T) and the others followed.

There were also concerns about two girls with learning difficulties and particularly passive behaviour. One girl (M) has English as a second language, and the other (P) was consistently victimised by T.

Aims of the intervention

1. To work towards improving the children's behaviour and performance through trying to help them develop a more positive image of themselves in the school context.

2. To work towards improving the negative dynamics between these children.

Selection of pupils

In order to work towards these aims, it was decided that:

1. T would attend the group (and this should also be used as an opportunity to separate him from L and allow him to form a more positive relationship with another boy).

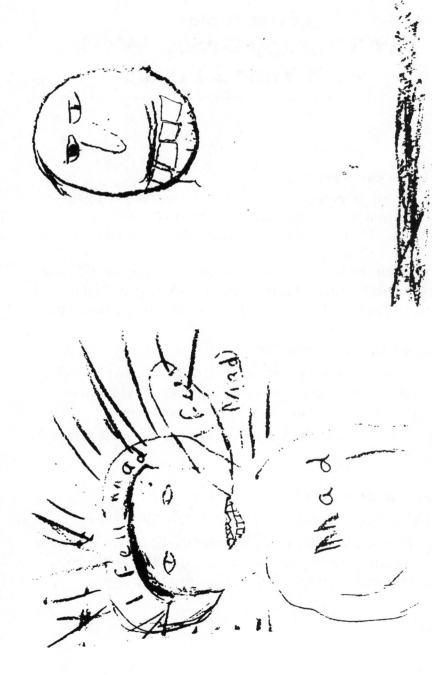

Figure 15b: Art therapy group work with Year 3 pupils

Figure 15a: Art therapy group work with Year 3 pupils

Figure 15c: Art therapy group work with Year 3 pupils

2. B, a child who is seen to be achieving well at school, would attend the group to allow a potential friendship between himself and T to develop, as well as to raise the status of the group.

3. M would attend the group, as a child with learning difficulties who could benefit from extra attention and encouragement to behave more assertively.

4. P (the girl victimised by T) would attend, as this would allow the opportunity to work towards changing this dynamic between them, as well as offering her more attention and greater status within the class.

Focus of the sessions

The sessions were introduced as a 'special project group' within the context of the class topic. Children were told they had been selected as a privilege. They developed their own folders of artwork around the theme 'feelings' (part of the topic).

This focus was chosen to allow the children to identify their attendance in the group in terms of 'schoolwork', and because it is a good vehicle for exploring affective, behavioural and other issues.

Outcomes

After one and a half terms of weekly sessions, the teacher has commented on significant changes. T is attempting to 'distance' himself from L and has formed a friendship with B. He has completely stopped bullying P. Both P and M appear more confident in the class generally and M, who was quiet to the point that no one could realistically assess her language support needs, now chats easily with the teacher. The level of disruption within the class as a whole has lessened.

EXAMPLE 2

Upper Junior
Art Therapy Group Work
with Year 5 pupils

Focus of concern

Seven children had been identified in this class as being excessively withdrawn and vulnerable. Several of them have extremely stressful home situations. All suffered chronic bullying in the playground, appeared isolated in relation to their peers, and were unwilling to participate in an active way in their class. They seemed low on confidence in their schoolwork.

Aims of the intervention

1. To raise the children's level of confidence and self-esteem.

2. To encourage them to behave more assertively with their peers.

3. To raise their status within the class as a whole through their selection for a special project.

4. To improve their communication and interactive skills.

Focus of the sessions

The group was withdrawn weekly for a 'special art project' on 'Our rights and responsibilities'. This focus was chosen to fit into class work by the teacher on behaviour, and was a vehicle for exploring their own vulnerability and discuss strategies for dealing with 'unfair' behaviour from other children. They worked collaboratively on a

picture book. Work was organised around group 'brainstorms', followed by art-making sessions, with sharing and feedback.

Outcome

After two terms of weekly sessions, the teacher has found that, with one exception, the children were participating more actively within the classroom context. There were three children, in particular, whose level of confidence seemed to have improved significantly. (One of these children even put himself forward for the class play.)

One child, however, used the sessions to express some very disturbing things, which enabled the school to identify him as a child needing additional specialist attention. He was referred to Child Guidance.[1]

1 Using this approach with children who are bullied is described in detail in my chapter 'Conflict at school: The use of an art therapy approach to support children who are bullied' in M. Liebmann (ed) (1996) *Arts Approaches to Conflict*. London: Jessica Kingsley Publishers.

MY RIGHTS

To be safe

Not to be harmed

To defend myself

Not to be bullied

To be cared for and protected

To my own religion

To an education

To my own feelings

To my own thoughts and ideas

To make an honest mistake

To be proud of who I am

To tell someone if something bad is happening to me

Not to be stolen from

MY RIGHT TO AN EDUCATION

To work without interruption

To have a quiet working environment

To come to school every day

To be safe and not to be bullied

To learn

To ask questions

To follow the teacher's instructions

To admit I need help or don't know something

To make an honest mistake

To do my best

To use the equipment I need

THIS IS HOW I FEEL WHEN SOMEONE TAKES AWAY MY RIGHTS

Miserable

My heart is pumping

Upset

Really angry

Scared

Lonely

Hurt

Like I want to go home

Shocked

It's not fair

Scrunched up inside

Like I'm not there

Weak and small

Like hitting them

Like no one cares about me

Like I want to give up

Jealous

THIS IS HOW I FEEL WHEN
I STAND UP FOR MY RIGHTS

Not angry

Proud

Brilliant

Strong

Not weak

Powerful

Fantastic

Wonderful

Big

Good

Happy with myself

THESE THINGS INTERFERE
WITH MY RIGHT TO AN EDUCATION

Noise

Too much talking and laughing and shouting

To have equipment I'm using taken away

To be shy or too scared to ask questions

To be interrupted by other children

To be bullied

Not going to school

To be afraid to make mistakes or try

STANDING UP FOR MY RIGHTS

Do	*Don't*
Tell the person to leave me alone	Don't take away someone else's rights
Tell the teacher or a grown up	Don't fight
Say what I want	Don't make threats
Compromise	Don't look scared
Stand up and look confident	Don't look weak
Ask questions if I need to	Don't be afraid to ask questions

BODY LANGUAGE

Mouth

Eyes

Posture

Hands

Voice

Shoulders

Expression

What is it saying?

I have the right to use the equipment I need

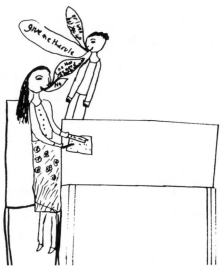

Figure 16a: Art therapy group work with Year 5 pupils – 'My right to an education'

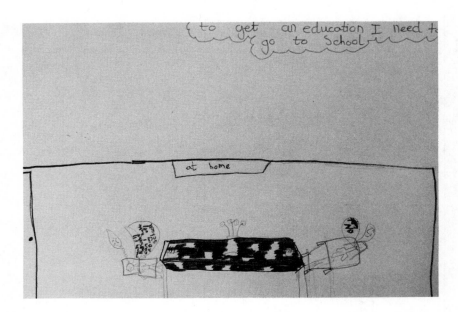

Figure 16b: Art therapy group work with Year 5 pupils – 'This is how I feel when I stand up for my rights'

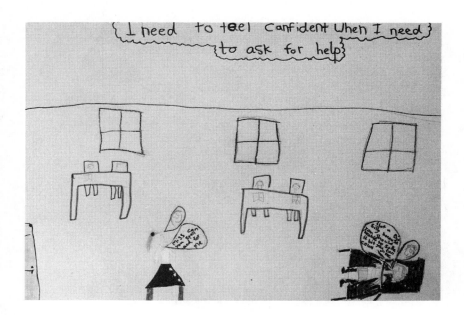

Figure 17a: Feeling confident

Figure 17b: How I feel when I'm bullied

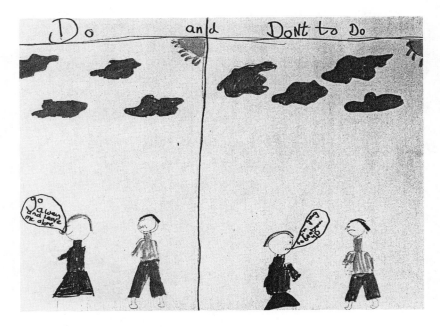

Figure 18: Art therapy group work with Year 5 pupils – 'Do/Don't'

Figure 19: Art therapy group work with Year 5 pupils – 'This is how I feel when someone takes my rights away'

Thank you for the lessons we had. I thought the book was good to do and I had a great time. I learned all about our rights and standing up for our rights.

From N.

Thank you for teaching us. We liked the book and we were proud of it.

From S.

It as good and exciting with you. I liked drawing about my feelings and acting in our play when we were pushing each other around like we shouldn't do.

From A.

Thank you for the lesson. The best bit I liked was talking about feelings. I liked coming to the lesson and learning something.

From M.

I liked working with you. I liked doing the pictures about confidence and I liked doing the book. It was very good and was really fun. I enjoyed it. I liked doing plays. I did it with J and I was the one who was asking for his money. I liked all of the stuff.

From T.

EXAMPLE 3

Lower Secondary
Art Therapy with the Whole Class Group as a Strategic Intervention

Focus of concern

Teachers were becoming increasingly alarmed at the way one class was locked in a cycle of disruptive behaviour and negative relations with each other and their teachers. They had acquired the label of 'worst class in the school' amongst staff and also described themselves in these terms. They were uncooperative and unable to work together.

Aims of the intervention

1. To change their image of themselves as a class to a more positive one.

2. To develop a more cooperative attitude.

3. To improve their ability to work collaboratively.

Focus of the sessions

The class was working on the theme 'ourselves' in their PSE lesson and we explored related topics through art activities. These were intended to provide the opportunity for the pupils to share their thoughts, experiences and ideas, allow the teacher and myself to give them positive feedback and value their contributions, and promote sharing and listening skills.

Outcome

Three sessions helped to shift the behaviour and self-image of this class. It created a situation whereby their teacher was able to award them a 'class merit' (which pleased them enormously) and establish an expectation of cooperative behaviour and good work. Their teacher felt very enthusiastic about the impact of the art therapy sessions. The improvement was noted by other lesson teachers and sustained the following year.

Figure 20a: Art therapy with the whole class group as a strategic intervention

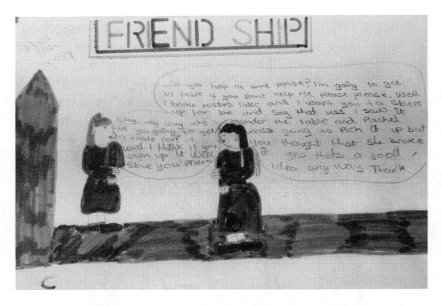

Figure 20b: Art therapy with the whole class group as a strategic intervention

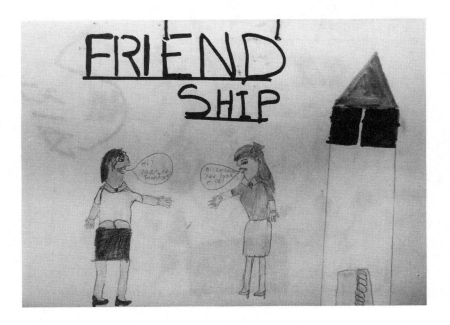

Figure 20c: Art therapy with the whole class group as a strategic intervention

EXAMPLE 4

Top Junior
Art Therapy with the Whole Class Group of Year 6 Pupils

Focus of concern

This class had been through a long period of change and disrupted routines. They had had a series of different teachers in rapid succession (as well as a succession of acting head teachers). They were unsettled, untrusting and uncooperative. They were giving their (newly qualified) teacher an extremely difficult time and seemed to be trapped in a spiralling dynamic of negativity.

Aims of the intervention

1. To support the children's self esteem and improve their group identity.

2. To increase their willingness to cooperate.

3. To support the development of a more positive relationship between the class and their teacher.

4. To reduce the 'macho ethic' among some of the boys.

Focus of the sessions

These sessions were introduced in terms of artwork to support the term's topicwork. Much emphasis was put on introducing it as a forum for generating their own ideas and thoughts, with no 'right or wrong' way of doing it. The sessions were approached by creating a situation where the teacher was able to express interest, appreciation and enjoyment in response to the children, thereby developing a more

positive interaction. Cooperation and supportive behaviour among the children was strongly noted and rewarded with praise.

Outcome

After three sessions, the relationship between the class and their teacher began to improve significantly. (She commented that, for the first time, she found she enjoyed being with them.) The growing cooperative atmosphere was then built upon and consolidated in subsequent lessons. As 'sharing and caring' gained status, some of the extreme 'macho' behaviour began to decrease.

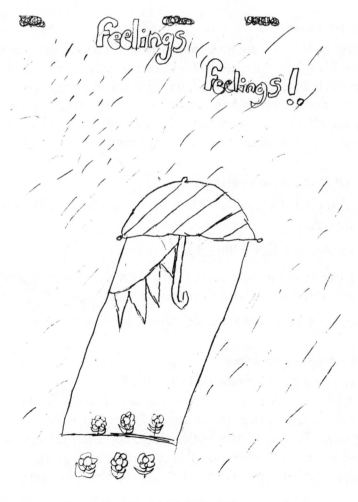

Figure 21a: Art therapy with the whole class of Year 6 pupils

Figure 21b: Art therapy with the whole class of Year 6 pupils

EXAMPLE 5

Lower Junior
Art Therapy Group Work
with Individual Year 4 Pupils

Focus of concern

B was causing great concern. He was very withdrawn and had long periods without speaking or responding, with occasional bursts of disruptive behaviour. As he disliked being 'singled out' it was decided he should work together with another child (K) who was also marginalised within the class, but functioning at a higher level than B.

Aims of the intervention

Essentially diagnostic – the sessions were used to try to 'unpick' what's behind the way B isolates himself and his withdrawal, and possibly identify strategies for supporting him within the classroom.

Focus of the sessions

The boys were told they were going to work on a special project to do their 'autobiographies' in art ('Me Books'). They made book covers and chose titles, and each session added another page about themselves or their feelings about something (decided by them-selves). This was used as the basis for talking together and offering support. The sessions went on weekly, over the summer term.

Outcome

The class teacher found the feedback from the sessions enormously helpful. She felt it offered insight into B's behaviour which gave her

an understanding of how she could work with him in class and liaise with his mother. Practical strategies for supporting B and containing his outbursts were also suggested.

The teacher discussed Child Guidance with B's mother, but felt it was unlikely to happen. She felt B needed support beyond the scope of the classroom and wanted to organise continued support within the school context. Individual art therapy sessions were organised for him the following year (at school), which he attended happily. His progress has been so significant that his teacher declared she was no longer concerned about him at the end of the year.

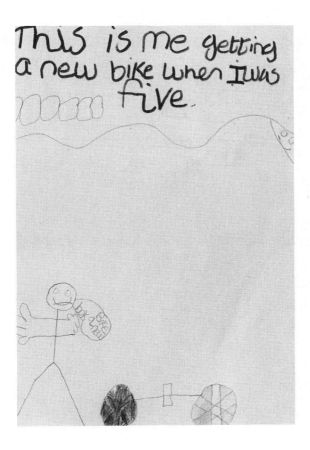

Figure 22a: Art therapy group work with individual Year 4 pupils

This is a picture of
Me going to the beach
When I was three
years old.

Figure 22b: Art therapy group work with individual Year 4 pupils

Figure 22c: Art therapy group work with individual Year 4 pupils

Figure 22d: Art therapy group work with individual Year 4 pupils

EXAMPLE 2 OF THE CONTENTS
PAGE OF ONE CHILD'S 'ME BOOK'

Contents

This makes me jealous

This is me going on holiday to see my family

This makes me cry

I love it when I get a new bike

I hate it when someone trips me over

This is me getting a new bike when I was five

EXAMPLE 6

Junior School
Art Therapy Group Work
with Year 5 Pupils

Focus of concern

This class was dominated (both in numbers and behaviour) by the boys and the teacher was concerned that the girls were withdrawn and marginalised. Four girls in particular were causing concern: I, M, N and R (whose family has recently immigrated to Britain and was very quiet and shy).

Aims of the intervention

To 'raise the profile' of these girls and offer them extra attention and status and to work on confidence building and self-assertion.

Focus of the sessions

The girls were 'chosen' to do a special project on 'Confidence'. They were asked to produce a joint book which they would present to the class at the end of the project. This was used as the basis for discussing their fears and anxieties about school and how they could cope with these.

Outcome

The impact of the sessions became apparent almost immediately, with all four girls taking a more active role within the classroom. However, the change in R was most dramatic. She became talkative and confident and, most significantly, proudly shared details about her

family's background and religion, as well as coming forward to report incidents of bullying she faced in the playground.

Two important issues emerged which the girls disclosed in the sessions: that they were afraid to ask questions in case they 'looked stupid or silly' and that several boys were bullying them 'on the quiet' within the classroom (e.g. taking their equipment, spoiling their work, threatening them if they complained). The teacher was then able to take measures to address these issues back in class.

Figure 23a: Art therapy group work with Year 5 pupils

Figure 23c: Art therapy group work with Year 5 pupils

Figure 23b: Art therapy group work with Year 5 pupils

Figure 24: Art therapy group work with Year 5 pupils – 'Confidence'

CONFIDENCE

Feeling OK

Feeling good about myself

Not feeling worried

Not going to cry

Knowing I can do it

Feeling strong

Knowing I can make new friends

Being friendly

Knowing I can do well

Facing new situations

GROUP PROJECT
ON CONFIDENCE

Situations where I need to feel confident:

If I've been away a long time

Going to a new school

Going to a new place

Asking for help from the teacher

When no one is my friend

If I can't do something

When someone is unkind to me

If I'm going to see a friend I had a fight with

EXAMPLE 7

Primary–Secondary Transfer
Art Therapy with the Whole Year 7 Class Group

Focus of concern

One Year 7 class was not settling down to secondary school and had high proportions of very disruptive and troubled children. They were not functioning well as a whole class group and were very demanding individually and collectively.

Aims of the intervention

1. To focus on group building (building trust, cooperation and confidence) with this class in order to improve their levels of functioning.

2. To support them during their adjustment to the demands of secondary school.

3. To create a situation whereby the pupils in the class groups could feel good about themselves individually as learners, by feeling they were achieving well.

4. To move into building a positive image of themselves as a whole class group (as a 'good class').

5. To help them move towards increasing awareness of how to behave and work together, and what prevents them from doing well as a class group.

Focus of the sessions

Art activities were presented over two terms in the context of the PSHE syllabus. Term one's module focused on 'sharing, listening, communicating, building confidence and trust'. Term two's module focused on 'Social Relationships – feelings and friendships'.

Children worked on a 'Book about me' over the two terms. The project book format was familiar and allowed some continuity with their primary school experience. The art activities were selected in terms of the scope they offered for airing and sharing anxieties, fears and upsets, as well as group building and confidence building.

Liaison with other staff

Meeting with the form tutor and other staff to share concerns and discuss strategies to back up our 'positive approach' were an essential element of the intervention. Both the teachers and the form tutor were very committed and understood the aims of the project.

Back-up support for individual students

Counselling was provided on an individual and very small group basis to back up and reinforce the whole class intervention with children who needed the extra support.

Outcomes of the Intervention

The class has settled down well to life in secondary school. They are now able to work better together and take responsibility for their behaviour and work, and are more aware of what is required to learn. (This has been observed on both a collective and individual basis.) Children will take responsibility for moving away from each other and regrouping to stop disruptive behaviour.

Other teachers now describe them as a 'nice class' and comment that the children are 'friendly', 'enthusiastic' and 'amenable'.

Figure 25b: Art therapy with the whole Year 7 class group

Figure 25a: Art therapy with the whole Year 7 class group

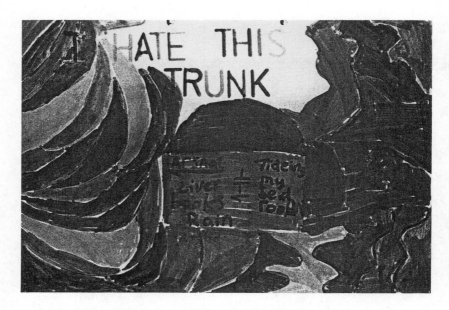

Figure 25c: Art therapy with the whole Year 7 class group

EXAMPLE 8

Lower Junior
Individual Art Therapy
Sessions
with a Year 3 Pupil

Focus of concern

T displayed excessive levels of anxiety and behaved in an inappropriate way with his peers. He had poor representational skills and tended to go off into 'a world of his own'.

Aims of the interventions

1. Diagnostic
2. Developing specific strategies regarding:
 i. reducing anxiety
 ii. increasing social appropriateness
 iii. developing representational skills.

Focus of the session

Activities were presented within the term's topic of 'our neighbourhood'.

Outcome

The following observations and specific strategies emerged from the individual sessions with T:

1. Reducing anxiety:

One of the initial concerns about T expressed by staff and parents was the excessive level of anxiety he displayed. It appeared that there may be a link between this anxiety and T's apparent difficulty in negotiating social context and understanding what was expected. From the work undertaken with T, I developed the following strategies for supporting him back in the classroom:

- being very clear over what to do (and what not to do)
- breaking down an activity into precise areas where possible
- frequent feedback and encouragement
- reassurance/information about the time (e.g. for each activity; when playtime is; etc.), which was an area of constant anxiety.

2. Social appropriateness:
 In my discussions with both his current and previous teachers, T's lack of socially appropriate behaviour was highlighted as a major concern. His present teacher commented that she felt T frequently did not understand what was happening around him and was also concerned that other children were finding T increasingly odd.
 It appeared that T needed to be helped to recognise and understand socially appropriate behaviour. (He seemed to be confused rather than acting out.) I developed the following strategies from the sessions:

 - structuring social interaction into clear components (e.g. talking, listening, responding, sharing, developing an idea further)
 - confidence building (that he has interesting things to say; that he is a valuable person)
 - interactive games (which will group build and help him 'connect' with other children)

○ fostering other children's respect for him (e.g. through modelling, taking him seriously, highlighting his contributions)

3. Representational skills:

T's skills in graphic representation were poor (this has in fact been cited as an area of concern in his record of special needs on file). It seemed that T may have been failing to understand the concept of graphic representation and that working with him to develop this skill could be important in helping him to clarify and analyse his environment through recording his surroundings and representing his experiences (which could also help increase his own sense of control and reduce anxiety). I outlined the following approach:

○ giving help to develop the use of drawing in a representational way (e.g. of the world around him; an experience; a storyline)

○ increasing clarity and analysis within his drawing (e.g. through helping him to relate the image to the object; through building up images with him to clarify their component parts).

Outcome

The strategies developed in the individual sessions helped with the management of T's needs and behaviour back in the classroom. It also highlighted the serious nature of his difficulties and his need of specialist help. It promoted effective liaison between the class teacher and the head teacher and brought in outside agencies and parents.

Figure 26: Individual art therapy with a Year 3 pupil

'ME' WORK IN THE
CONTEXT OF TOPICWORK
ON 'OUR NEIGHBOURHOOD'

My Neighbourhood

My neighbourhood is where I live and the area around it. My neighbourhood has lots of shops in it. There are lots of dogs in my neighbourhood. There are lots of cats too.

There are lots of places to go in my neighbourhood and lots of people live there.

There are lots of buses in our neighbourhood. They are red and green. They go to all different places. You get them at the bus stop.

School is when you learn to do things. R........... is my school. Maths, reading and writing are very important to learn. When you play in the playground you have to be careful not to get hurt.

We go to the shops to buy food. At Christmas time, most people buy turkey. Sometimes you buy food to fry.

I play games at home and people play in the park.

EXAMPLE 9

Upper Junior
Individual Art Therapy Sessions with a Year 6 Pupil

Focus of concern

L was extremely withdrawn with occasional outbursts. He appeared to have a very low self-esteem and was ostracised by most other children, who said he smelled bad. (He soiled himself on occasions.)

Aims of the intervention

1. Diagnostic appraisal (for assessment procedures).

2. To provide space for him to talk and be listened to (providing a forum for identifying specific issues for him).

3. To raise his confidence.

4. To raise his self-esteem through increasing his sense of his own rights and visibility as a person.

5. To liaise closely with his class teacher.

Focus of the sessions

Art activities were presented within the context of the term's history topic 'Past and Present'.

Outcome

1. Raising Confidence:
 I worked for some time with L on increasing his sense of his 'right' to stand up for himself and to consider himself worthy of respect. His teacher has been reinforcing this back in the classroom. Recently, his teacher has seen evidence that L is beginning to assert himself, especially in terms of situations where he is being bullied.

2. Self-esteem:
 Working towards increasing L's self-esteem had been a central focus of my work with him. To support this back in the classroom, it was decided that his teacher would:

 ○ create opportunities for him to feel important (e.g. special responsibilities, recognition for his good work)

 ○ create opportunities for him to feel competent (e.g. through tasks/activities he was successful at)

3. Diagnostic:
 During the time I worked with L, it became apparent that he had much pain and many 'secrets' and he was anxious to talk to someone. (For example, after the first half term, he disclosed to his teacher that he had been soiling himself.) It was clear that L needed ongoing professional help and required an enormous amount of support to be able to cope with the demands of secondary school. I sent a report as part of a formal assessment procedure.

THE INTRODUCTION
TO THE CHILDREN'S BOOK

Past, present and future

The past is what happened before now. It is yesterday and the day before.

It is a long time ago.

The present is now. It is today. It is the age we are now. It is the times we live in.

The future is what is going to happen but hasn't happened yet. It is tomorrow and the day after that. It is next year. It is the next decade or century.

This book is about our past, present and future. It shows pictures of old memories and events from our past. It shows our ideas about what our future will be like when we are older.

EXAMPLE OF THE CONTENTS
OF ONE CHILD'S BOOK

Contents

I Past

 1. An accident in the past

 2. Feeling bad about the accident

 3. Picture about the feeling from the accident

II Present

 4. Working in the present

 5. Things I like about myself now

 6. How I'm feeling today

III Future

 7. An accident I might have in the future

 8. An argument I might have with my dad

 9. How the argument will make me feel

Figure 27a: Individual art therapy with a Year 6 pupil

Figure 27b: Individual art therapy with a Year 6 pupil

EXAMPLE 10

Secondary
Using an Art Therapy Approach to Explore Sensitive Topics with the Whole Class

Focus of concern

The PSHE Coordinator felt that some areas of the syllabus were especially sensitive to teach (such as aspects of sex education, relationships, abuse, bereavement). Challenging classes presented additional difficulties when the ability to reflect, empathise and approach the subject maturely were required in order to deal with it satisfactorily.

Aims of the intervention

1. To explore ways of using an art therapy approach to support the teaching of sensitive topics.

2. To provide a 'way in' for pupils to reflect on difficult issues.

3. To provide a basis for discussing these issues in an empathetic and sensible way.

Focus of the sessions

After the topic was introduced by a 'trigger' story, the class was asked to assume the viewpoint of one of the characters and produce an image reflecting their feelings and experiences. This was used as a basis for exploring beliefs and the issues involved.

Back-up support for students

Counselling or art therapy sessions were provided on an individual basis to students for whom these issues were pressing and needed additional support.

Outcome

Pupils were able to share and engage in genuine discussions. They went on to produce writing which was truly reflective and showed understanding. Such was the quality of their artwork and writing that they developed it as a presentation at a school assembly (where it was well received).

Figure 28a: Using an art therapy approach to explore sensitive topics with the whole class

Figure 28b: Using an art therapy approach to explore sensitive topics with the whole class

EXAMPLE 11

Secondary
Art Therapy Sessions with a Year 8 Pupil

Focus of Concern

E arrived at the school having moved from another part of Britain under traumatic circumstances. She had recently experienced great loss and bereavement. Her behaviour was very disruptive and she was unable to settle into school. She had changed classes within a term of arriving and was having difficulties relating to her peer group.

Aims of the Intervention

1. To give E additional support while she adjusted to her new circumstances.

2. To provide the opportunity for her to share and reflect on what had happened and how she felt about it.

3. To liaise with the teacher with responsibility for pastoral care and EBD to develop strategic support to E within the school.

Focus of the sessions

Sessions were presented as time and space for E. She was allowed to bring whatever issues she wanted to the sessions and determine the agenda.

Outcome

E used the individual support sessions very fully. She brought a range of concerns to them and appreciated the opportunity to express some

of the emotions she was carrying inside and had been dealing with
on her own.

Gaining an insight into the nature of her distress enabled more
effective school support to be developed in liaison meetings with
staff, as well as contributing to the statementing process the school
was attempting to initiate. ·

Figure 29a: Art therapy sessions with a Year 8 pupil

Figure 29b: Art therapy sessions with a Year 8 pupil

Useful Reading and Resources

Borba, M. (1989) *Esteem Builders*. Jalmar Press.

Campbell, J. (1993) *Creative Art in Groupwork*. Bicester: Winslow Press.

Capacchione, L. (1989) *The Creative Journal*. Newcastle Publishing Company Inc.

Crary, E. (1984) *Kids Cooperate: A Practical Guide to Problem Solving*. Parenting Press.

Dokter, D. (1994) *Arts Therapies and Eating Disorders*. London: Jessica Kingsley Publishers.

Dyregrove, A. (1991) *Grief in Children – A Handbook for Adults*. London: Jessica Kingsley Publishers.

Grunsell, A. (1989) *Let's Talk about Bullying*. Gloucester Press.

Liebmann, M. (1986) *Art Therapy for Groups*. London and New York: Routledge.

Liebmann, M. (1991) *The Use of Art in Working with Conflict*. Occasional Paper No. 6. Bristol: Mediation UK.

Liebmann, M. (1996) *Arts Approaches to Conflict*. London: Jessica Kingsley Publishers.

Mediation UK, (1990) *Conflict Resolution and Schools*. Training Paper 2F. Bristol: Mediation UK.

Mosley, J. (1991) *All-Round Success*. Trowbridge: Wiltshire County Council.

Munro, E.A. *et al.* (1983) *Counselling: A Skills Approach*. London: Methuen.

Nicholas, F.M. (c.1987) *Coping with Conflict: A Resource Pack for the Middle School Years*. Learning Development Aids.

Ross, C. and Ryan, A. (1990) *Can I Stay in Today Miss?*. Stoke on Trent: Trentham.

Ross, C. (1996) 'Conflict at school – The use of an art therapy approach to support children who are being bullied.' In M. Liebmann (ed) *Arts Approaches to Conflict*. London: Jessica Kingsley Publishers.

Stores, R. (1993) *Good Grief: Exploring Feelings, Loss and Death*. Volume One and Two (second edition). London: Jessica Kingsley Publishers.

White, M. (1991) *Self-Esteem: Its Meaning and Value in Schools. How to Help Children Learn Readily and Behave Well*. Cambridge: Daniels Publishing.